MW00811439

Peter Piper's Practical Principles of Plain and Perfect Pronunciation

A STUDY IN TYPOGRAPHY

Willard Johnson

Introduction by
Harry Miller Lydenberg

DOVER PUBLICATIONS, INC.
Mineola, New York

Bibliographical Note

This Dover edition, first published in 2015, is an unabridged republication of the work originally published by Mergenthaler Linotype Company, Brooklyn, N.Y., in 1936. [First publication: Willard Johnson, Philadelphia, 1836.]

Library of Congress Cataloging-in-Publication Data

Johnson, Willard.
 Peter Piper's practical principles of plain and perfect pronunciation : a study in typography / Willard Johnson ; Introduction by Harry Miller Lydenberg.
 pages cm
 Includes index.
 Originally published by Mergenthaler Linotype Company, 1936.
 ISBN-13: 978-0-486-80282-4
 ISBN-10: 0-486-80282-5
 1. English language—Pronunciation. 2. Nursery rhymes. 3. Alphabet books. 4. Tongue twisters. 5. Alphabet. I. Lydenberg, Harry Miller, 1874–1960. II. Title.
PE1137.J544 2015
421'.52—dc23

 2015009128

Manufactured in the United States by RR Donnelley
80282501 2015
www.doverpublications.com

Peter Piper's Practical Principles of Plain and Perfect Pronunciation

A STUDY IN TYPOGRAPHY

Designed by Bruce Rogers

Set in Linotype Cloister, with
Linotype (Cleland) Decorative Material

Peter Piper's Practical Principles of Plain & Perfect Pronunciation

MERGENTHALER LINOTYPE
COMPANY · BROOKLYN · N · Y

[Original 1936 title page]

L

INTRODUCTION

BY

HARRY MILLER LYDENBERG

WILL YOU TELL ME, please, why we have this "painless dentistry" when it comes to "book learning," but nowhere else?

I'm not bright enough or swift enough ever to try for a plumber's helper or an electrician's assistant, or get a grudging assent to a work out for even a minor league team. But I have seen the plumber's helper getting his instruction, and I fail to recall any words or acts from the plumber except a few decisive indications of an expectant and insistent assumption that the young gentleman would be ready with the Still-

son when that particular wrench was needed, would pass it on because he knew what the plumber wanted, had got this knowledge at the hands of that best of all teachers, Dame Experience, and had appreciated it when safely stowed away as a man appreciates only those things he holds dear and acquires by the sweat of his brow.

When it comes to books, however, particularly those that tell us how to read and write and learn other things in school, one of the most impressive things about them is the way they try to make this learning so sweetly alluring, simple, easy. The pill's there all right, but the coating is thick, fascinating.

To be sure, that's just one more way of saying that the real teacher tries to use the yeast of interest to raise and lighten that mass of sodden dough he's faced with and told to make into a loaf of bread. And the teacher who understands this drives his mark deep into the youthful mind, with gratitude from one side and satisfaction from the other.

Simple and plain enough, to be sure, but just as certainly it is one of the things that come over us with new light whenever we look at a lot of school books, or hark back to the teachers we recall as stimulating

and inspiring. When you get the reflex of outstanding personality you find a lighthouse with beams that go far and give mighty aid. That lacking, the thing we remember most clearly either in teacher or textbook is the way we kicked against the pricks when faced with that particular bit of school work.

Look at any collection of old school books and you will always find the guide to right living, *Spiritual Milk for Boston Babes*, the shorter or longer catechism setting forth the conclusions and definitions of assemblies of divines, texts undoubtedly as effective in raising heat resistance when they first appeared as when you yourself faced them in later days.

Then there are the plain unmitigated fact presenters, *Geography Epitomized*, the *History of Ruritania*, the *Science of Numbers*, often with a *New* set in front to stir a passing wave of curiosity and to make you hope that if all the other books failed to teach you how to bound Kentucky or to find the square root of xyz this one will finally do the impossible.

But I fancy that of all the memories of all the text books we ever absorbed, or resisted with might and main, those that stay with us longest are either the story books or the stunt books, tongue twisters, para-

dox presenters. Few there be who do not recall at
least one startling maze of words, at least one impos-
sible combination of figures that solved itself neatly
when once you got the clue and used your head. And
the book you got that from sticks in your memory,
either as to text or illustrations.

Those books are of course nothing more than the
twinkle in the eye, the confidential wink, as the
teacher tells the class he knows all along that he's
been passing out things difficult to swallow, but after
all they are not so hard to down if only you'll say it
this way or do it thus.

And even closer to us than those are the real stories,
*Goody Two Shoes and Her Alphabet, Cock Robin,
The House that Jack Built, Dick Whittington and
His Cat, Struwelpeter,* the *Grand Panjandrum, La
Fontaine, Perrault, Andersen, Grimm, Peter Pan,
Pinocchio, Aesop* the eternal and universal.

The younger set is fortunate in having seen Walter
Crane, Randolph Caldecott, Kate Greenaway, How-
ard Pyle give such lasting demonstration of the ap-
peal and response to and from the sympathetic artist
and his boy and girl readers. And the illustrators of
the books we buy today are in many cases living up

INTRODUCTION

nobly to the traditions passed on by those who ran
the race before them.

But for all time the text book is a cradle book, an
incunabulum, in more ways than one. Every one
knows about the Gutenberg Bible, but sometimes we
forget about the Donatus printed at the same time if
not before, and so lovingly—or otherwise—used by
childish hands as to have disappeared in complete
copies. We see Bibles and church books and histories
—all sorts of books—appearing in those cradle days,
but we don't want to forget that one of the first things
those printers did when they discovered this new art
and craft of making many copies at the same time by
means of movable blocks of wood or metal, was to
print a grammar, a school book.

And their followers have jogged along in their foot-
steps. John Foster began to print in Boston in 1675,
and a short catechism appeared from his press the
next year (Evans, 222). Dr. Rosenbach's collection
begins with *The Rule of the New-Creature to Be
Practised Every Day*, dated Boston, 1682. And his
printed record stops with 1836, the date of *Peter
Piper's Practical Principles of Plain and Perfect Pro-
nunciation*.

[9]

PETER PIPER'S

PRACTICAL PRINCIPLES

OF

PLAIN AND PERFECT

PRONUNCIATION.

PHILADELPHIA:

WILLARD JOHNSON, No. 141, SOUTH STREET.

1836.

Original title page slightly reduced

INTRODUCTION

This *Peter Piper* is almost as much of our common heritage as *The Star Spangled Banner* or *The Boy Stood on the Burning Deck*. Nay, I'm sure that more people can finish its lines, once you set them going, than can give you the second stanza as Francis Scott Key or Felicia Dorothea Hemans sent them forth.

I recently amused myself by asking the first dozen men I met and knew well enough to stop with such a question, "Tell me, please, the first half dozen things you remember?" Sometimes they told about a ride in the buggy or a drive in the rain with one of the parents, sometimes how a mother tried to get them to help with household chores, sometimes a struggle with brother or sister over a coveted place at table or a plate of porridge. There were almost as many different phases of child life as there were men who answered the question.

But in almost every case appeared a book or a reading exercise or a family or school sing, in some shape or other. Now it was the father trying to get him to say ABC as the letters were traced. Now it was the dawning of the idea that c-a-t and the picture formed merely two ways of saying the same thing. But it was usually some form of the printed or written page they

had held in memory, some form or other of a book that was even now as sharp and vivid a memory as the things they did or ate or played with.

And here—it makes me feel as if I too were trying to point a moral or inculcate paths of righteousness, both far from my plan—is something people cannot say too often or too emphatically to the writers and designers and printers of books for boys and girls, namely that the things they say and the way they say them are going to stay with those youngsters much longer and much closer than many they read and wrestle with in later years.

So obvious, of course, as to call for apology for saying it. But, just the same, it's important enough to make us glad to know that here some twenty-five printers who know they practice an art as well as a craft have set themselves the task of doing today, in today's fashion and manner, a piece of work already familiar to us in form and text for many generations.

The facts about *Peter* are quickly stated. It was in 1836 that Willard Johnson published his text at 141 South Street in Philadelphia, and if you turn to Dr. Rosenbach's catalogue of his early American children's books you will find between pages 286 and 287

INTRODUCTION

a charming reproduction of the cover, black print on
a yellow or orange sheet that surely must have cap-
tured the eye and fancy of any child that saw it, also
the P p page showing Peter himself.

Miss Sowerby's note for the 1836 entry is detailed
and final, telling how the book was first published by
J. Harris in St. Paul's Churchyard at London many a
year before it appeared on this side of the water; the
first American edition made its bow through Carter
Andrews and Company at Lancaster, Massachusetts,
about 1830.

At the end is a Hymn. And so, children, remember

> Then what I want to do amiss,
> However pleasant it may be,
> I'll always try to think of this—
> I'm not too young for God to see!

CONTENTS

PETER PIPER'S

PRACTICAL PRINCIPLES

OF

PLAIN & PERFECT

PRONUNCIATION

Designed by Peter Beilenson

Set in Linotype Erbar Light Condensed

P-P-P-PREFACE

Peter Piper, without Pretension to Precocity or Profoundness, Puts Pen to Paper to Produce these Puzzling Pages, Purposely to Please the Palates of Pretty Prattling Playfellows, Proudly Presuming that with Proper Penetration it will Probably, and Perhaps Positively, Prove a Peculiarly Pleasant and Profitable Path to Proper, Plain and Precise Pronunciation. He Prays Parents to Purchase this Playful Performance, Partly to Pay him for his Patience and Pains; Partly to Provide for the Printers and Publishers, but Principally to Prevent the Pernicious Prevalence of Perverse Pronunciation

Designed by John S. Fass

Illustration adapted
from a Sixteenth Century Woodcut

Set in Linotype Janson Italic
and Caslon Old Face

a A a

Andrew Airpump ask'd his Aunt her ailment;

Did Andrew Airpump ask his Aunt her ailment?

If Andrew Airpump ask'd his Aunt her ailment,

Where was the ailment of Andrew Airpump's Aunt?

Designed by Joseph Blumenthal

Illustrated by Fritz Eichenberg

Set in Caslon Old Face Italic
on the All-Purpose Linotype, with
enlarged Caslon Old Face letters

b B

Billy Button bought a butter'd Biscuit:
Did Billy Button buy a butter'd Biscuit?
If Billy Button bought a butter'd Biscuit
Where's the butter'd Biscuit Billy Button
bought?

Designed by G. Gehman Taylor and
George F. Trenholm

Illustrated by George F. Trenholm

Typography by G. Gehman Taylor

Set in Linotype Scotch, Bodoni Bold
and Poster Bodoni

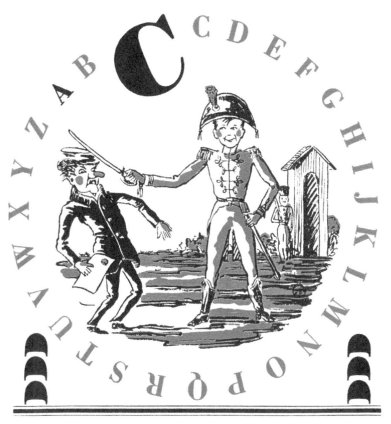

Captain Crackskull crack'd a
 Catchpoll's Cockscomb:
Did Captain Crackskull crack a
 Catchpoll's Cockscomb?
If Captain Crackskull crack'd a
 Catchpoll's Cockscomb,
Where's the Catchpoll's Cockscomb
 Captain Crackskull crack'd?

Designed and Illustrated by
W. A. Dwiggins

Set in Linotype Bodoni
with Linotype Decorative Material

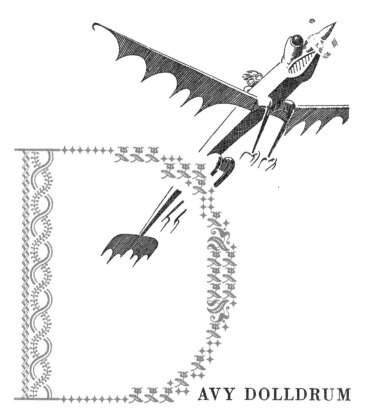

AVY DOLLDRUM
dream'd he drove a Dragon:
Did Davy Dolldrum dream he drove a dragon?
If Davy Dolldrum dream'd he drove a dragon,
Where's the dragon Davy Dolldrum dream'd he drove?

d

Designed by Nelson Amsden

Illustrated by Corydon Bell

Set in Linotype Caslon Old Face

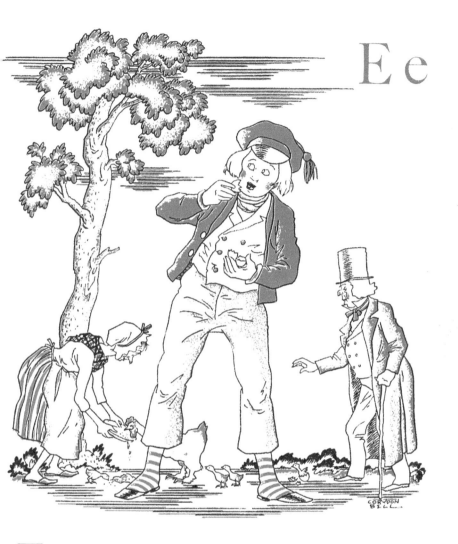

E e

Enoch Elkrig ate an empty Eggshell:
Did Enoch Elkrig eat an empty Eggshell?
If Enoch Elkrig ate an empty Eggshell,
Where's the empty Eggshell Enoch Elkrig
 ate?

Designed by Charles R. Capon and
Fred Anthoensen

Illustrated by Charles R. Capon

Typography by Fred Anthoensen

Set in Linotype Electra and Bodoni Bold,
with Linotype Decorative Material

F-f

Francis Fribble figured on a Frenchman's Filly:

Did Francis Fribble figure on a Frenchman's Filly?

If Francis Fribble figured on a Frenchman's Filly,

Where's the Frenchman's Filly Francis Fribble figured on?

Designed by Edwin and Robert Grabhorn

Illustration by John Tenniel
from *Alice in Wonderland*
(Lee & Shepard, Boston, 1869)

Set in Caslon Old Face and Italic
on the All-Purpose Linotype

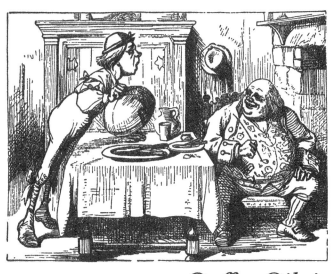

Gaffer Gilpin
got a Goose and Gander:
Did *Gaffer Gilpin*
get a Goose and Gander?
If *Gaffer Gilpin*
got a Goose and Gander,
Where's the Goose & Gander
Gaffer Gilpin got?

Designed by Edmund B. Thompson

Illustrated by Valenti Angelo

Set in Linotype Estienne, with
Linotype Decorative Border

[34]

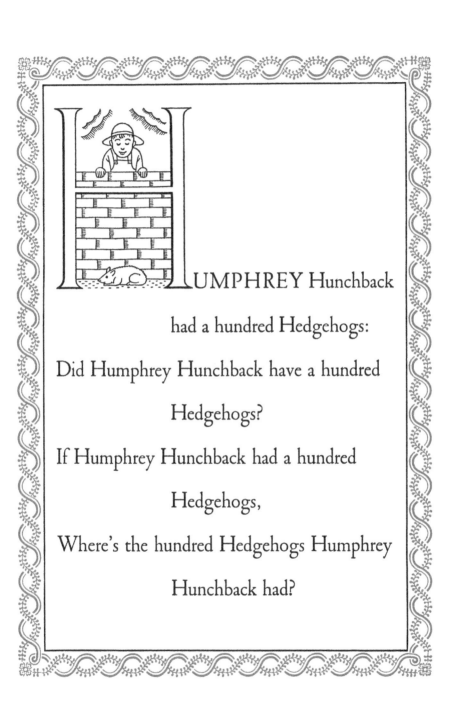

UMPHREY Hunchback

had a hundred Hedgehogs:

Did Humphrey Hunchback have a hundred

Hedgehogs?

If Humphrey Hunchback had a hundred

Hedgehogs,

Where's the hundred Hedgehogs Humphrey

Hunchback had?

Designed by John Archer

Illustrated by Joseph Low

Set in Linotype Scotch and
Caslon Old Face Italic

Iɴɪɢᴏ Iᴍᴘᴇʏ itched for an Indian Image:

Did Inigo Impey itch for an Indian Image?

If Inigo Impey itched for an Indian Image,

Where's the Indian Image Inigo Impey itch'd
for?

Designed by Helen Gentry

Illustrated by Anne Heyneman

Set in Caslon Old Face Italic
on the All-Purpose Linotype

Jumping Jackey jeer'd
a Jesting Juggler:
Did Jumping Jackey jeer
a Jesting Juggler?
If Jumping Jackey jeer'd
a Jesting Juggler,
Where's the Jesting Juggler
Jumping Jackey jeer'd?

Designed by Ernst Reichl

Illustrated by Donald P. Bennett, age nine

Set in Linotype Antique No. 3
and Antique No. 1

K k

Kimbo Kemble
 kick'd
 his Kinsman's
 Kettle:

Did
 Kimbo Kemble
 kick
 his Kinsman's
 Kettle?

If
 Kimbo Kemble
 kick'd
 his Kinsman's
 Kettle,

Where's the Kinsman's Kettle
 Kimbo Kemble kick'd?

Designed and Illustrated by
Howard Trafton

Typography by Paul A. Bennett

Set in Linotype Gothic Condensed No. 2

1929 1930 1931 1932 1933

Lanky Lawrence lost his Lass and Lobster:
Did Lanky Lawrence lose his Lass and Lobster?
If Lanky Lawrence lost his Lass and Lobster,
Where are the Lass and Lobster Lanky Lawrence lost?

Designed by Edward Alonzo Miller

Illustrated by Lucina Wakefield

Set in Linotype Janson

Mm

Matthew Mendlegs miss'd a mangled Monkey:

Did Matthew Mendlegs miss a mangled Monkey?

If Matthew Mendlegs miss'd a mangled Monkey,

Where's the mangled Monkey Matthew Mend-
legs miss'd?

Designed by James and Cecil Johnson

Set in Linotype Scotch Italic
and Caslon Old Face

Nn

Neddy Noodle nipp'd his neigh-
bour's Nutmegs:

Did Neddy Noodle nip his neigh-
bour's Nutmegs?

If Neddy Noodle nipp'd his neigh-
bour's Nutmegs,

Where are the neighbour's Nut-
megs Neddy Noodle nipp'd?

Designed by Heyworth Campbell

Illustrations from Type Specimen Books,
Bruce Foundry, 1882; Dickinson Foundry, 1883

Set in Linotype Erbar Bold Condensed

Oliver Oglethorpe ogled an Owl and Oyster:

Did Oliver Oglethorpe ogle an Owl and Oyster!

If Oliver Oglethorpe ogled an Owl and Oyster,

Where are the Owl and Oyster Oliver Oglethorpe ogled!

Designed and Illustrated by
John Averill

Set in Linotype Scotch

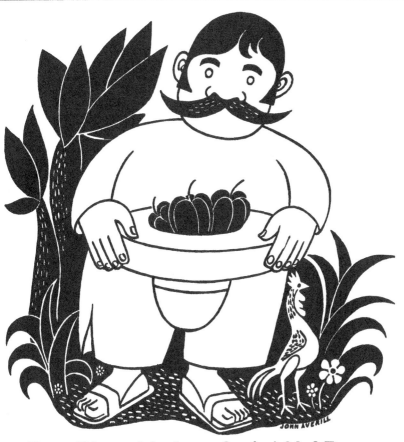

Peter Piper picked a peck of pickled Peppers

Did Peter Piper pick a peck of pickled Peppers?

If Peter Piper picked a peck of pickled Peppers,

Where's the peck of pickled Peppers

Peter Piper picked?

Designed by Milton Glick

Illustrated by Boris Artzybasheff

Set in Linotype Baskerville, with
enlarged Baskerville Q

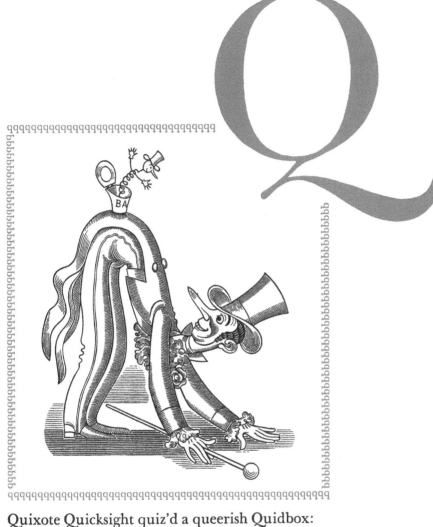

Quixote Quicksight quiz'd a queerish Quidbox:

Did Quixote Quicksight quiz a queerish Quidbox?

If Quixote Quicksight quiz'd a queerish Quidbox,

Where's the queerish Quidbox Quixote Quicksight
quiz'd?

Designed by Arthur W. Rushmore

Illustrated by Leo Manso

Set in Linotype Baskerville, with
enlarged Baskerville, Granjon Italic
and Bodoni Italic letters
and Electra florets

R R r

Rory Rumpus rode a raw-bon'd Race-horse:

Did Rory Rumpus ride a raw-bon'd Race-horse?

If Rory Rumpus rode a raw-bon'd Race-horse,

Where's the raw-bon'd Race-horse Rory Rumpus rode?

Designed and Illustrated by
Raymond Lufkin

Set in Linotype Metroblack No. 2

SAMMY SMELLIE smelt a smell of Small-coal:
Did Sammy Smellie smell a smell of Small-coal?
If Sammy Smellie smelt a smell of Small-coal,
Where's the smell of Small-coal Sammy Smellie smelt?

Designed by Lester Douglas

Illustrated by Charles Dunn

Set in Linotype Caslon Old Face

TtTtTtTt tTtTtT

Tip-toe Tommy turn'd a Turk for Two-pence:

Did Tip-toe Tommy turn a Turk for Two-pence?

If Tip-toe Tommy turn'd a Turk for Two-pence?

Where's the Turk for Two-pence *Tip-toe Tommy turn'd?*

Designed and Illustrated by
Robert Foster

Set in Linotype Poster Bodoni

U

Uncle's Usher urg'd an ugly

Urchin: Did Uncle's Usher

urge an ugly Urchin? IF

Uncle's Usher urg'd an ugly

Urchin — Where's the ugly

Urchin Uncle's Usher urg'd?

FOSTER

✠ Marks the spot where last seen

Designed and Illustrated by
Clarence P. Hornung

Set in Linotype Baskerville

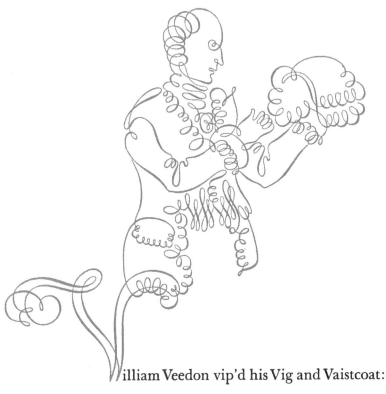

illiam Veedon vip'd his Vig and Vaistcoat:

Did Villiam Veedon vipe his Vig and Vaistcoat?

If Villiam Veedon vip'd his Vig and Vaistcoat,

Where are the Vig and Vaistcoat Villiam
 Veedon vip'd?

Designed by Carl Purington Rollins

Illustrated with
Linotype ornaments and All-Purpose Linotype
Metro No. 2 Family letters

Set in Linotype Metrolite No. 2
and Metroblack No. 2

WALTER WADDLE won a WALKING WAGER:

Did **Walter Waddle** win a Walking Wager?

If Walter Waddle won a Walking Wager,

Where's the Walking Wager **Walter Waddle** won?

Designed and Illustrated by
Georg Salter

Typography by Melvin Loos

Set in Linotype Electra

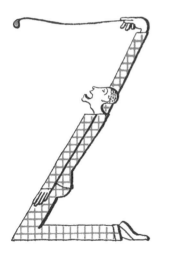

X Y and Z have made my
 brains to crack-o:
X smokes, Y snuffs, and
 Z chews tobacco;
Yet oft by X Y Z much
 learning's taught,
But PETER PIPER, beats
 them all to nought.

Designed and Written by
Bruce Rogers

(This page was not in the 1836 edition)

Set in Linotype Caslon Bold Condensed

& now comes Ambling Ampers& as tailpiece gr&.
 No letter? Ah!
But still so fine & d&y, h&some, bl&,
 &c.,
That if my h& had at comm& an alphabetter
 'Alphasgood,
I'd print a b&box full of Haight's B&Books
 In loving mood.

Though Einstein's fame is f& through all the l&s
 For relativity,
It's relatively one-stone less than &'s
 For conjunctivity.
& though we'd pl& to cut this caper, y'underst&,
 On made-by-h& paper,
Amalgamating Ampers& dem&s this BR&
 Of Ampers&paper.

A HYMN

I'm not too young for GOD to see:
 He knows my name and nature too,
And all day long he looks at me,
 And sees my actions through and through.

He listens to the words I say,
 And knows the thoughts I have within,
And whether I'm at work or play,
 He's sure to see me if I sin.

Oh! how could children tell a lie,
 Or cheat in play, or steal, or fight,
If they remembered GOD was by,
 And had them always in his sight!

If some good minister is near,
 It makes us careful what we do;
And how much more ought we to fear
 The LORD who sees us through and through.

Then when I want to do amiss,
 However pleasant it may be,
I'll always try to think of this —
 I'm not too young for GOD to see!

A NOTE ON THIS BOOK

THE INSPIRATION for this adventure in bookmaking was a charmingly-colored page showing Peter Piper, reproduced in Dr. A. S. W. Rosenbach's *Early American Children's Books* (Southworth Press, Portland, Maine, 1933). To the appeal of that page was added Dr. Rosenbach's comment in his introduction to that book: ". . . I sometimes think that my favorite of all is that immortal tongue-twister, Peter Piper's Practical Principles of Perfect Pronunciation . . ." Here was sufficient urge to hunt up the 1836 edition.

It wasn't easy to locate the book, for several Americana dealers knew nothing of it. Finally the hunt led where it might well have begun, to The New York Public Library, where a copy was carefully preserved.

A NOTE ON THIS BOOK

Through the courtesy and interest of the Director, Dr. Harry M. Lydenberg, permission was granted to have it photostated.

The artists, designers and printers, whose delightfully diverse solutions to a common problem appear on preceding pages, were invited to redesign an allotted page in any manner they pleased. Each was furnished with a photostat of the original page, each was free to do the page without restriction in style or technique, and without hampering suggestions. There was no hint that the page should carry a period, contemporary, or a "modern" flavor. There was no limitation to the selection of a Linotype face to set the text. The pages were completed by the contributors between October 1935 and April 1936.

That this was a labor of love—both for the delight of children and for the interest of those within the Graphic Arts—is patent by the result. Lest cynics scorn, it should be revealed that no contributor received recompense for his or her contribution; all were delighted to participate in the undertaking. An extract from one letter of acceptance is indicative of what, perhaps, was an almost common feeling: "Thanks for the privilege of participation. The fact

of the matter is, I have been rather fed up on my present bread and butter work and this opportunity acts on me like a Spring tonic—even though it is about ten below zero outside . . ."

In total, forty-one individuals have made this book—none of them, obviously, had any idea of what his adjacent neighbors were planning. To each of them, appreciation for an undertaking excellently accomplished. We are particularly indebted to four gentlemen who "doubled in brass": To Mr. Bruce Rogers, who, in addition to arranging the delightful title page, also devoted an April week-end to devising and writing the amusing *Ambling Ampersand* page; to Mr. John S. Fass, who arranged the front matter and other pages in addition to the *Andrew Airpump* page; to Mr. W. A. Dwiggins, who was responsible for the binding design in addition to his *Davy Doll-drum* page; and to Dr. Harry M. Lydenberg, who found time in a busy existence to pen the *Introduction* to this book, and to counsel in its ramifications.

It was my privilege to institute this unique collection. To each contributor, and to the Company who financed its publishing, I am deeply grateful.

PAUL A. BENNETT

WHO'S WHO

[*Title Page*] BRUCE ROGERS. Born 1870, Lafayette, Ind. Designer of Books. Graduate Purdue University, B.S., 1890, honorary L.H.D., 1932. Honorary M.A. degree, Yale University, 1928. Member, art staff, *Indianapolis News*, 1891; designer, Indiana Illustrating Company, 1892-1894. To Boston, Mass., with L. Prang & Co., 1895. In charge of limited editions and general typography at The Riverside Press, Cambridge, Mass., 1895-1912. Independent designer in New York, 1913-1916, assisting Museum Press of The Metropolitan Museum of Art. Designed Montaigne and Centaur type faces. In 1917 and later, associated with Emery Walker in London, Printing Adviser, Cambridge University Press, Cambridge, England, 1917-1919. Printing Adviser, Harvard University Press, Cambridge, Mass., 1920 to date. In charge of limited editions and fine printing at The Printing House of William Edwin Rudge, Mt. Vernon, N. Y., 1920-1928. Among his many distinguished books are The Riverside Press editions of: *The Essays of Montaigne*, 1902-1904; *The Parlement of Foules*, 1904; *The Song of Roland*, 1906, and *Geofroy Tory*, 1909. *The Centaur* (Montague Press), 1915. The Grolier Club editions of: *Franklin and His Press at Passy*, 1914; *Of the Just Shaping of Letters*, 1917; *The Pierrot of the Minute*, 1923; *Champ Fleury*, 1927, and *Fra Luca De Pacioli*, 1933. *Ancient Books and Modern Discoveries* (Caxton Club, 1927). *The Odyssey of Homer* (Emery Walker, Ltd., 1932). His master-

piece is the magnificent *Lectern Bible* (Oxford University Press, 1935). Awarded Gold Medal of The American Institute of Graphic Arts, 1925, "for distinguished achievement in typography." An honorary member of the following clubs: Book Club of California, San Francisco; Club of Odd Volumes, Boston; John Barnard Associates, Cambridge, Mass.; Caxton Club, Chicago; Quarto Club, New York; Grolier Club, New York; Double Crown Club, London, England. (In addition to designing the TITLE PAGE of this edition, Mr. Rogers has also been responsible for AMBLING AMPERSAND, page 53.

[*Introduction*] HARRY MILLER LYDENBERG. Born 1874, Dayton, Ohio. Director of The New York Public Library. Harvard College, A.B., 1897. Cataloguer, Lenox Branch, N.Y.P.L., 1896; in charge manuscripts, N.Y.P.L., 1896-1899; Assistant to Director, N.Y.P.L., 1899-1908, Chief Reference Librarian, N.Y.P.L., 1908-1927; Assistant Director, N.Y.P.L., 1928-1934. Author: *History of The New York Public Library*, 1923; *Life of John Shaw Billings*, 1924; *Paper or Sawdust— A Plea For Good Paper For Good Books*, 1924; *The Care and Repair of Books* (with John Archer), R. R. Bowker Co., 1931. Editor: *Archibald Robertson, Lieutenant-General, Royal Engineers, His Diaries and Sketches in America*, 1762-1780, 1930.

[*Preface*] PETER BEILENSON. Born 1905, New York, N.Y. Proprietor, The Walpole Printing Office (printing) and, with Mrs. Beilenson, The Peter Pauper Press (publishing), both of Mount Vernon, N.Y. College of the City of New York, 1925; Printing House of William Edwin Rudge, 1926-1928; Press of the Woolly Whale, 1928-1929; Village Press (Fred-

eric W. Goudy) parts of 1927 and 1928. With Edmund B. Thompson founded Walpole Printing Office, 1929. Notable books designed: *Batouala* (Limited Editions Club, 1932); *An Immoral Anthology*, 1933; *Prelude to Man*, 1936.

[A] JOHN S. FASS. Born 1890, Lititz, Pa. Vice-President in charge of design and production, The Harbor Press, New York. Worked in a country newspaper office until after the War, then in various shops in Philadelphia and New York, including The Printing House of William Edwin Rudge. Notable books designed: *Arabia Infelix and Other Poems* (Fountain Press, 1929); *The Study of Incunabula* (Grolier Club, 1933); *Typee* (Limited Editions Club, 1935); *Nursery Rhymes of New York City*, illustrated by Ilse Bischoff, 1931; *The Other Don Juan*, illustrated by Steele Savage, 1932; and *A Trip to the Prairies*, 1934, the latter three printed and published by The Harbor Press. ¶In addition to designing the ANDREW AIRPUMP page of this edition, Mr. Fass has also been responsible for the typography of the HALF TITLE, INTRODUCTION, CONTENTS, HYMN, A NOTE ON THIS BOOK, WHO'S WHO, and the INDEX OF TYPE FACES pages.

[B] JOSEPH BLUMENTHAL. Born 1897, New York, N. Y. Director, The Spiral Press, New York. Cornell University, class of 1919. Designer of the Spiral type, now being cut by English Monotype, to be known as Emerson. Instructor in Printing Design and Production at the New School, New York. Notable books designed: *The Day of Doom* (Spiral Press, 1929); *Collected Poems of Robert Frost* (Random House, 1930); *The Lyrics of Francois Villon* (Limited Editions Club, 1933); *Poems of W. H. Auden* (Random House, 1934); *A Further Range* (Henry Holt and Co., 1936), etc.

[B] FRITZ EICHENBERG. Born 1901, Cologne, Germany. Artist, Illustrator, Wood Engraver. Studied art in Cologne, Germany, 1918-1923, and at The Academy of Graphic Arts, Leipzig, 1923-1925, specializing in wood-engraving, lithography and etching. For eight years staff artist, The Ullstein Press, Berlin. Illustrated German editions of *Gulliver's Travels* and *Till Eulenspiegel* (Feuer Verlag, Leipzig, 1923); *Crime and Punishment* (Singer Verlag, Leipzig, 1924); as well as various modern children's books for Schneider Verlag, Leipzig, 1925-1931. Contributed articles and drawings to *Uhu*, the German satirical periodical. Travelled extensively as a correspondent for various magazines and newspapers in England, France, Italy, Austria, Guatemala and Mexico. A collection of his woodcuts is in the Bibliographic Museum of Leipzig. Member American Artists' Congress; conducting workshop in Illustration at the New School, New York.

[C] GEORGE F. TRENHOLM. Born 1886, Cambridge, Mass. Artist and Designer, studio in Boston. Educated in Somerville, Mass., designed headbands, initials and decorations for school paper. Early work in art department for a color printing concern, then an engraving house. Studied under Charles E. Heil, the Boston painter; Votjech Preissig, in the Graphic Arts Class at Wentworth Institute; general design at The Massachusetts Normal Art School in Boston. In 1927, designed the alphabet of old style letters used in U.T.A. Apprenticeship Training course; three type faces (Trenholm Old Style, Trenholm Cursive, Trenholm Bold) for Barnhart Brothers and Spindler, and a variety of decorative ornaments and borders for the same foundry. Designed Georgian Cursive, 1934, for Machine Composition

Company, Boston. In 1935, won first award (book type classification) in the contest sponsored by the Advertising Typographers of America. Member, The Society of Printers, Boston; Boston Club of Printing House Craftsmen; Boston Advertising Club; The Stowaways, New York; Guild of Free Lance Artists, New York, etc.

[C] G. GEHMAN TAYLOR. Born 1884, Quakertown, Pa. President, The Abbey Press, Gordon-Taylor, Inc., Cambridge, Mass. Designer, Typographer and Printer, Lecturer on layout at Boston schools and organizations. Has won several prizes in various typographic and printing contests, and honorable mention in The American Graphic Arts Leaders exhibit. Experience in layout, eighteen years; printed *The Time Machine* for Random House, 1931, under supervision of W. A. Dwiggins, "one of the thrills of my life." Member, The American Institute of Graphic Arts, The Society of Printers, Boston. Hobby: Collecting the work of famous designers he knows, and golf. Evidently not bad at golf, having won the annual prize of the Graphic Arts Associates of New England three times.

[D] W. A. DWIGGINS. Born 1880, Martinsville, Ohio. Designer, Calligrapher, Illustrator, Typographer. Student in Frank Holme's School of Illustration, Chicago, 1899-1901, tutors Frederic W. Goudy, F. X. and J. C. Leyendecker, John B. McCutcheon. Later, worked as free lance designer for printers and advertisers in Chicago, moving to Boston, Mass., in 1904. Acting Director, Harvard University Press, 1917-1918. Published three numbers of *The Fabulist*, with Laurance B. Siegfried, 1915, 1916, 1921. Founded The Society of Calligraphers, Boston, 1919; first publication *Extracts*

WHO'S WHO

From *An Investigation Into the Physical Properties of Books As They Are Now Published.* Author of *Paraphs* (Alfred A. Knopf, 1928) via Hermann Puterschein; *Layout in Advertising* (Harper and Brothers, 1928); *Towards A Reform of the Paper Currency* (Limited Editions Club, 1932); various essays on lettering, design and typography for *Direct Advertising*, 1916-1927; a treatise on *Caslon's Type Flowers* (Society of Printers, Boston), and a monograph, *D. B. Updike and The Merrymount Press* (*The Fleuron*, No. 3, 1924). Designer of the Linotype Metro Series (Metrolite, Metroblack, Metrothin and Metromedium) and Electra type faces. Among the notable books he has designed, decorated or illustrated are *Ballades From The Hidden Way*, and *Elizabeth and Essex* (Crosby Gaige, 1928); *America Conquers Death* (William Edwin Rudge, 1928); *Strange Case of Dr. Jekyll and Mr. Hyde* (Random House, 1929); *Twenty-Two Printers Marks and Seals*, designed or redrawn by W. A. D. (William Edwin Rudge, 1929); *Poe's Tales* (Lakeside Press, 1930); *The Time Machine* (Random House, 1931); two Limited Editions Club titles, *Tartarin of Tarascon*, 1930, and Balzac's *Droll Stories*, 1932; *The Travels of Marco Polo* (Printing House of Leo Hart, 1933); *Emblems and Electra* (Mergenthaler Linotype Company, 1935); *One More Spring* (Overbrook Press, 1935). Typical trade editions designed for Alfred A. Knopf include *The Collected Prose of Elinor Wylie*, 1933; *Wells' Seven Famous Novels*, 1934; *Kristin Lavransdatter*, 1935. Awarded Gold Medal, American Institute of Graphic Arts, 1929, for "distinguished accomplishment in typographic design." Honorary member: The Society of Printers, Boston; The Double Crown Club, London. Hobby, Marionettes. ❡ In addition to designing DAVY DOLLDRUM, Mr. Dwiggins also designed the binding of this edition.

WHO'S WHO

[E] NELSON AMSDEN. Born 1888, Ashtabula, Ohio. Art Director and Designer. President, The Roger Williams Company, Cleveland and New York. Owned The Amsden Studio, Cleveland and Chicago. Helped develop such artists as John LaGatta, Fred Mizen, Alonzo Kimball, Charles R. Capon, Corydon Bell and others. Designed the Dobbs style of advertising; also special editions of Dickens' *The Seven Poor Travelers*, and *The Poor Relations Story*; and Hugh Walpole's *Mr. Huffam*, for The Roger Williams Company. Pioneered in the development of Direct Color Photography. Hobby: Building old sailing ships.

[E] CORYDON BELL. Born 1894, Tiffin, Ohio. Illustrator, Book and Advertising Designer. An enthusiast about early Nineteenth Century modes and manners, he created a characteristic style for Dobbs and Company advertising in 1924. Among the books he has designed and illustrated are: *Marionettes, Masks and Shadows* (Doubleday Page and Co.), one of the A.I.G.A. "Fifty Books" of 1927; and *Bag O' Tales* (E. P. Dutton Co., 1934). In collaboration with his wife, as author, several children's books, including *Black Face* (Doubleday, Doran and Co., 1931). For Doubleday, he has done many book jackets. Hobby: Painting humorous and satirical murals.

[F] CHARLES R. CAPON. Born 1885, Toronto, Canada. Designer and Typographer. Early education in Toronto. Studied law nine months. Then turned to Art, studied at the Ontario Academy of Design. Spent several years in Art Departments of advertising agencies and printers. Studied with Eric Pape in Boston, 1915. Became Art Director of The Amsden Studios in Cleveland, 1917. Served as a direc-

[83]

tor of Marine Camouflage until the end of the war. Studied
a year in Europe, 1923-1924. Has won six awards in poster,
trade mark, book plate, and typographic contests.

[F] FRED ANTHOENSEN. Born 1882, Portland, Maine.
Treasurer and Manager, The Southworth-Anthoensen Press,
Portland, Maine. Also in charge of design and typography.
Began as office boy in the plant of Marks Printing House,
Portland, Maine, 1897. Joined Southworth Press as composi-
tor in 1900, became plant manager in 1917. Notable books
designed: *The Narrative of Arthur Gordon Pym*, illustrated
by Rene Clarke (Limited Editions Club, 1930); *The Pearl*
(Oxford University Press, 1932); *The Thrifty Dreamer and
Other Poems*, 1929; *An Elegy Written in a Country Church-
yard*, 1930; *Early American Children's Books*, 1933; *Frank
Forester* (Carteret Book Club, 1933); *A Glossary of the Con-
struction, Decoration and Use of Arms and Armor*, 1934;
The Bashford Dean Collection of Arms and Armor, 1934;
The Clan Chisholm, 1935. All were printed, and some of
them published, by the Press.

[G] EDWIN and ROBERT GRABHORN. Born 1889 and
1900, respectively. (Edwin, 1889, Cincinnati, Ohio; Robert,
1900, Indianapolis, Ind.). Founded The Grabhorn Press,
San Francisco, 1920. Previously in Indianapolis, 1915-1919.
Items appeared under various imprints: The Studio Press;
R. Thatcher and E. Grabhorn; E. and R. Grabhorn and J.
McDonald. The Press has produced many books published
by The Lantern Press, The Book Club of California, John
Howell, The Westgate Press, Random House, etc. Among
the more than 150 books produced since 1919 are the follow-
ing, each one of the A.I.G.A. "Fifty Books of the Year":

1923 exhibition, *Sundry Ballades; The Song of Songs* (Book Club of California). 1924, *Oscar Weil, Letters and Papers* (Book Club of California). 1925, *Aldus Pius Manutius*, and *The Letter of Christopher Columbus* (Book Club of California). 1926, *The Philobiblon of Richard de Bury* (Book Club of California); *The Modern Writer* (Lantern Press). 1927, *The Letter of Amerigo Vespucci* (Book Club of California); *Francis Drake Along the Pacific Coast; The Book of Ruth.* 1928, *The Golden Touch; For Whispers and Chants* (Lantern Press); *A Journey to Lower Oregon and Upper California, 1848-49* (John J. Newbegin). 1929, *Around the Horn in '49* (Book Club of California); *The Scarlet Letter* (Random House); *The Voiage and Travaile of Sir John Maundevile, Kt.* (Random House). 1930, *Sonnets From Antan* (Fountain Press); *The Relation of Alvar Nunez Cabeca de Vaca; American Taste* (Westgate Press). 1931, *The Southern Mines of California; Leaves of Grass* (Random House). 1932, *The Santa Fe Trail to California, 1849-1852* (Book Club of California); *Speaking at Seventy* (Gelber, Lilienthal, Inc.); *The Subtyl Historyes and Fables of Esope; The Bible of the Revolution* (John Howell). 1933, *The Diary of Johann August Sutter.* 1934, *California As It Is and As It May Be; Narrative of Nicholas "Cheyenne" Dawson; California in 1851, The Letters of Dame Shirley.* 1935, *A California Gold Rush Miscellany; Bibliography of the Writings of Edgar A. Poe* (Russian Hill Private Press); *California in 1846; Pen-Knife Sketches; The Spanish Occupation of California; Round Table Sonnets* (University Club, San Francisco). 1936, *Life Among the Indians; Solstice and Other Poems* (Random House). ❡ In the foregoing listing of books, The Grabhorn Press is the publisher where no specific mention is given.

[85]

[H] EDMUND B. THOMPSON. Born 1897, New York. Typographer and Printer. Proprietor, Hawthorn House, Windham, Conn. Columbia University, class of 1918. Army service at the Mexican Border and in France. Printing House of William Edwin Rudge, 1925-1929, with an interval in 1928-1929 at The Georgian Press. In partnership with Peter Beilenson organized Walpole Printing Office, 1929. Withdrew in 1932 and established Hawthorn House at Windham, Conn., which operates as a small printing business with occasional publishing ventures. Notable books designed: *The House of the Seven Gables*, illustrated by Valenti Angelo (Limited Editions Club, 1935); *Miscellaneous Antiquities*, Numbers 6 to 11 (W. S. Lewis); *Cherry Ripe* (Hawthorn House, 1935).

[H] VALENTI ANGELO. Born 1897, Massarosa, Tuscany, Italy. Painter, Sculptor, Designer, Illustrator and Illuminator of Books. Exhibited paintings at Pennsylvania Academy of Art; Ferragil Galleries, New York; San Francisco Museum of Art, etc. Has both sculptures and paintings in various private collections and museums. Illustrated some thirty-odd books for The Grabhorn Press, San Francisco, 1926-1933. Notable among these are the Random House editions of *The Voiage and Travaile of Sir John Maundevile, Kt.*, 1928, *The Scarlet Letter*, 1928, *Leaves of Grass*, 1930, and *The Red Badge of Courage*, 1931; *The Letter of Amerigo Vespucci* (Book Club of California), 1926; *Robyn Hode* (Westgate Press), 1932; and these Grabhorn Press published volumes: *The Book of Job*, 1926; *Salomé*, 1927; *The Book of Ruth*, 1927; *Relations of Alvar Nunez Cabeca De Vaca*, 1929, and *The Subtyl Historyes and Fables of Esope*, 1930. Moved to New York in 1933 and was commissioned (by the

WHO'S WHO

Limited Editions Club) to illustrate *A Thousand Nights and A Night*, 1934; *The House of the Seven Gables*, 1935, and a hand illuminated edition of *The Rubaiyat of Omar Khayyam*, 1936. Established, in 1935, The Golden Cross Press to produce and publish fine hand illuminated books. The first two issued are *The Book of Esther* and *The Sermon on the Mount*, each printed by Edmund B. Thompson.

[I] JOHN ARCHER. Born 1886, Birmingham, Eng. Printer to The New York Public Library. In Printing Office, Carnegie Library of Pittsburgh, 1901-1910; with The New York Public Library, 1910 to date. Author: *The Care and Repair of Books* (with Harry Miller Lydenberg), R. R. Bowker Co., 1931. Member, Grolier Club, New York; Director, American Institute of Graphic Arts. Notable books designed: *Archibald Robertson, His Diaries and Sketches in America*; the first English translation of *The Geography of Claudius Ptolemy*; *American Historical Prints*; *Washington's Farewell Address*, all published by The New York Public Library.

[I] JOSEPH LOW. Born 1911, Coraopolis, Pa. Student, Painter, Engraver. Two years at University of Illinois, followed by three years in and out of odd jobs (truck driver, factory hand, steel worker, printer, etc.) with efforts at self-instruction in drawing and engraving. At Art Students League, New York, since October 1935; teachers: George Grosz, Vaclav Vytlacil.

[J] HELEN GENTRY. Born 1897, near Temecula, California. Printer, Typographer, in charge of Design and Production, Holiday House, New York. University of California, class of 1922. Established her own Press in San Francisco

1929, continuing to 1934. Collaborator (with David Green-hood) of *Chronology of Books and Printing* (Helen Gentry Press, 1933, and The Macmillan Co., 1936). Notable books designed: *Tom of Bedlam's Song*, decorations by Lowell Hawk (Helen Gentry, 1931); *Scoring Systems For Flowers and Gardens*, decorations by Frank Gregory (Hillsborough Garden Club, 1932); *The History of Tom Thumb*, illustrated by Hilda Scott (Helen and Bruce Gentry, 1934).

[J] ANNE HEYNEMAN. Born 1910, San Francisco, California. Artist. Illustrated two Helen Gentry books: *Rip Van Winkle* (Helen Gentry Press, 1934), and *Cock Robin* (Holiday House, 1935).

[K] ERNST REICHL. Born 1900, Leipzig, Germany. Designer, H. Wolff Book Manufacturing Co., New York, since 1931. University of Leipzig, Ph.D., 1924. Designer, Alfred A. Knopf, Inc., 1927, Art Director, Doubleday, Doran and Co., Garden City, L. I., 1928-1931. Of some 3,000 books he has designed in fifteen years, Mr. Reichl keeps thirty titles on his shelves and values these three: *November* (Roman Press, 1932), *Ulysses* (Random House, 1934), *Locos* (Farrar and Rinehart, 1936).

[K] DONALD P. BENNETT. Born 1926, Cleveland, Ohio. Student, fifth grade, Public School No. 150, Long Island City, N. Y. This youngster scrawls pictures when he isn't playing, which is seldom. The designer of the page, Mr. Ernst Reichl, admired some past sketches he had done for Christmas cards, asked for this picture, likes it. The youngster doesn't care for it now that he sees it in print, wants to withhold publication.

WHO'S WHO

[L] HOWARD ALLEN TRAFTON. Born 1897, New York, N.Y. Artist, Poster Designer, etc. Designer of Trafton Script. Instructor, the Art Students League, New York. Spends as much time as possible in Paris, at least four months annually, but still likes corn on the cob and baseball.

[L] PAUL A. BENNETT. Born 1897, Brooklyn, New York. Typographer and Copy Writer. In charge of Typographic Layout, Mergenthaler Linotype Company, Brooklyn, N.Y. Educated in New York schools; worked in various New York printing offices on composition, layout, etc., 1912-1917. Overseas service, machine gunner. In Cleveland, Ohio, 1919-1927, as Director of Typography, Fuller & Smith (advertising agency); Production Manager, Dunlap-Ward Advertising Co.; Advertising Manager, Chandler Motor Car Co.; Publicity Manager, Chandler-Cleveland Motors Corporation. With Mergenthaler Linotype Company since 1928. Contributor to various automotive trade papers, *The American Printer, P.M.; The Dolphin, No. 2,* etc. Lecturer on Graphic Arts, New York University, 1931-1933. Editor, *News-Letter, The American Institute of Graphic Arts,* 1934-1935; Editor, Books and Bookmakers department, *The Linotype News,* 1930 to date. Director, The American Institute of Graphic Arts.

[M] EDWARD ALONZO MILLER. Born 1889, Philadelphia, Pa. In charge of Design and Production, The Marchbanks Press, New York. Typographer with The Oswald Press, New York, 1917-1919; Production Manager, The Marchbanks Press, 1921-1927; Director of Printing at The Cranbrook Press, Bloomfield Hills, Mich., 1930-1933; returned to The Marchbanks Press in 1934.

WHO'S WHO

[M] LUCINA SMITH WAKEFIELD. Born 1895, Atlanta, Georgia. Artist. Early art training with her father, an architect. Later studied at the Art Students League, New York, and with Frederic R. Gruger. Illustrated book jackets for many publishers, including Doubleday, Dutton, Harcourt-Brace, Harper's, Appleton-Century. Among the books she has illustrated are *Pirate Plunder* (Harper and Brothers, 1927); *Westward: The Romance of the American Frontier* (D.Appleton and Co.,1930); *The Secret Cave* (E.P. Dutton and Company, 1930); *The Canape Book* (D.Appleton-Century Co.,1934).

[N] JAMES and CECIL JOHNSON. Born in Sydney, Australia, 1897 and 1900, respectively. Founded The Windsor Press, San Francisco, 1924, and comprise its personnel. James, the designer, typographer, pressman and author, has been in printing since 1913. Among the books he has written: *The Centaur, Everue and Other Poems*, 1927; *A Child of Adam*, 1927; *Studies in Sombre*, 1928; *Nocturne in St. Gaudens*,1929; *The Persian Garden*,1929; *Punch and Lady, A Version*,1932; etc. Cecil, his brother, is joint author of *A Goddess Walks Attended*,1930; compiler of a George Sterling bibliography, and has been associated with printing since 1924. Both brothers served with the Canadian forces in France. Among the forty odd books they have printed at The Windsor Press are the above, and *The Press of the Renaissance in Italy*, 1927; *The Triumphs of Petrarch*, 1928; *Mediaeval Latin Students Songs*,1928; *The Ackymals*,1929; *The Book of Thel*,1930; *A Bibliography of the Writings of George Sterling*, 1931; *Oriental Eclogues*, 1932; *Printers' Flowers*,1933; *The Book of the Machine*,1934; *A Printer's Garland*,1935.

WHO'S WHO

[O] HEYWORTH CAMPBELL. Born 1886, Philadelphia, Pa. Format Editor and Designer for publishers, Writer, Lecturer. Created formats for *Everybody's Magazine, Vogue, Vanity Fair, House and Garden, Literary Forum, Sportsman, The Morning Telegraph* (New York), *Architectural Forum, Harper's Bazaar, House Beautiful, Town and Country, World Petroleum.* Edited and designed *The Body Beautiful* (Dodge Publishing Co., 1935). Designed advertising for General Motors, R. H. Macy and Co., Atwater Kent, Sterling Silversmith's Guild, *Good Housekeeping,* and Lederle Laboratories. Advertising for Marshall Field won Harvard Award, 1929. Second president, Art Directors Club, New York. Now contacting *Business Week, Arts and Decoration, Travel, Diesel Progress, Decorator's Digest,* American Radiator, Lucien Lelong, Charak. Hobbies: Cats and rifle shooting.

[P] JOHN AVERILL. Born 1900, Gayoso, Missouri, a town no longer on the map—the Mississippi River washed it away. Designer of Advertising and Printing, Commercial Artist. In 1911, printer's devil in a country newspaper office; high school, art school, unimportant cartoonist (he says) at the Chicago *Herald Examiner* and for trade papers. Made Sears Roebuck mail order catalog layouts, discovered typography and design, did general studio work. Art Director, Rogers & Co., Chicago; Free Lance designer, working for R. R. Donnelley Sons & Co., Chicago, among others. Now designing advertising and printing with Mills Novelty Co., Chicago. Prize possessions: A small typographic library; Contax camera; Luther, a Dachshund pup, and a comparatively late model Ford. Personal weakness, sweepstakes tickets.

WHO'S WHO

[Q] MILTON GLICK. Born 1904, Willard, Ohio. In charge
of Design and Production, The Viking Press, New York.
Graduate, Harvard College, 1926. Worked in shops of The
Mercury Press, Ltd., Chelmsford, Essex, England, 1926-
1927; The Printing House of William Edwin Rudge, Mt.
Vernon, N. Y., 1927-1928. Since November, 1928, with the
Viking Press. Married Evelyn Harter, 1933.

[Q] BORIS ARTZYBASHEFF. Born 1899, Kharkov, Russia.
Designer, illustrator, engraver. Came to United States in
1919. Painted murals and stage settings. Illustrated more
than twenty-five books, including: Creatures, 1927; Orpheus,
1930; Behind Moroccan Walls, 1931; all three published by
Macmillan; Gay Neck, 1928 (Dutton); Three and the Moon,
1929 (Alfred A. Knopf); Aesop's Fables, 1933; and The Cir-
cus of Doctor Lao, 1935, both published by The Viking
Press. Has exhibited at The New York Public Library; The
Brooklyn Museum; Salon d'Antoinne, Paris; Leggett Gal-
lery, Waldorf Astoria, New York; and The Ferargil Galleries,
New York.

[R] ARTHUR W. RUSHMORE. Born 1883, Brooklyn, N. Y.
In charge of Design and Production, Harper and Brothers,
New York. Joined Harper organization around the turn of
the century, headed Production Department for years and
years. Started The Golden Hind Press in Madison, New Jer-
sey (his home) in 1927, as a hobby—like the postman who
collected stamps. Notable books designed: Fatal Interview,
1931; Sonnets From the Portuguese, 1932; Jesus As Teacher,
1935; each published by Harper and Brothers; and, with
Warren Chappell, The Anatomy of Lettering (Loring and
Mussey, 1935).

WHO'S WHO

CRꓹ LEO MANSO. Born 1914, New York, N. Y. Illustrator, Designer, Painter. Awarded Metropolitan Art School scholarship, 1928; winner of many School Art League medals. Studied at National Academy, 1930; later with Arthur Schneider, the painter. Planned and conducted various advertising campaigns as Art Director for First Division Pictures. At present designing book jackets and painting.

CSꓹ RAYMOND LUFKIN. Born 1897, Salem, Mass. Artist. Free lance designer, Boston, Mass., 1922-1933; New York, 1934 to date.

CTꓹ CHARLES DUNN. Born 1895, Washington, D. C. Painter, Illustrator, Cartoonist, Caricaturist. Staff artist, *Nation's Business*. Award winner in many art competitions, first medal award Washington Society of Artists, 1925, Corcoran Gallery of Art. Exhibitor: Chicago Art Institute, Pennsylvania Academy of Art, National Academy of Design, New York, Corcoran Biennial, Washington Arts Club. Illustrated two Lester Douglas books: Dickens' *A Christmas Carol*, and *Three Men of Persia* by Ralph Bradford.

CTꓹ LESTER DOUGLAS. Born 1893, New York, N. Y. Director, Art and Typography, *Nation's Business* and U. S. Chamber of Commerce. Book, magazine and advertising designer, playtime cartoonist. Attracted to typography during his 'teens, handled magazine formats for *The American Magazine* and *Crowell Publishing Co*. As advertising agency executive planned all types of campaigns, directing art and typography for twelve years. Notable books designed: *The Gospel According to Saint Luke*, illustrated by Hans Foy, and *The Gospel According to Saint John*, illustrated by

C 93 ꓹ

Lewis Daniel (Judd & Detweiler, 1930, 1931); *Robbins' Journal* (Conde Nast Press, 1931); *The Travels of Marco Polo* (Limited Editions Club, 1934); wrote and designed *Color in Modern Printing* for Frederick H. Levey Co., New York, 1931.

[U] ROBERT FOSTER. Born 1895, State College, Penn. Graphic Artist, Poster and Cover Designer. Pennsylvania State College, class of 1917, Mechanical Engineering. Art editor, college comic *Froth*. United States Navy, during the World War. Two years in engineering work. 1921 to date: contributor, *Woman's Home Companion*; packaging and poster work for Atlantic Refining Company, Philadelphia, Pa., athletic program covers for University of Pennsylvania; designer of Pericles and Foster Abstract type faces, abstract sculptor. Instructor in Design at Pratt Institute, Brooklyn, New York. Exhibitor in England, Germany, France, Holland and Austria.

[V] CLARENCE PEARSON HORNUNG. Born 1899, New York, N. Y. Free Lance Designer. Educated in New York schools, and the College of the City of New York. Early work, beginning in 1920, was decorative design in traditional period styles for American Piano Company, Bartlett-Orr Press, Mergenthaler Linotype Company, R. R. Donnelley & Sons Company, American Type Founders Company, etc. Since 1926 has specialized in trade-mark design, book and bookbinding design, interior decoration, product and package design. Designed books for many publishers; bindings for *Encyclopaedia Britannica*, *Standard Encyclopedia*, *Dictionary of American Biography*, Scribner's, Harper's, Alfred A. Knopf, H. Wolff Estate, Limited Editions

Club, etc. Typographic initials and decorative elements designed for American Type Founders Company include: Vogue, Georgian, and Lexington Initials, Wedgewood Cameos, Pen Flourishes. Author of numerous articles for *Advertising Arts, Direct Advertising, The American Printer, Contemporary Books*. Among the books he has written and designed are: *The Bookplates of Harold Nelson* (Caxton Press, 1929); *Trade-Marks by Clarence Hornung* (Caxton Press, 1930); *A Handbook of Designs and Devices* (Harper and Brothers, 1932).

[W] CARL PURINGTON ROLLINS. Born 1880, West Newbury, Mass. Printer, Writer, Designer. Printer to Yale University, New Haven, Conn. Educated at Newburyport High School and Harvard. Worked on Georgetown (Mass.) *Advocate* as editorial writer, compositor, mailing clerk and press feeder. Worked for Heintzmann Press, Boston, as book compositor 1901-1903. Operated New Clairvaux Press, Montague, Mass., 1903-1905. Chief, Department of Graphic Arts, Jamestown Exposition, Norfolk, Va., 1907. Ran (and was run by) Montague Press, Dyke Mill, Montague, Mass., 1907-1918. With Yale University Press, 1918 to date. Honorary M.A. Yale University, 1920; Medalist, American Institute of Graphic Arts. Conductor of The Compleat Collector department (with John Winterich) in *The Saturday Review of Literature*, New York. Of the hundreds of books he has designed, forty-three were selected for the annual "Fifty Books" exhibitions of The American Institute of Graphic Arts, 1923-1936. Of this group (all published by Yale University Press unless otherwise indicated) are: 1923 exhibition, *Journal of a Lady of Quality; History of St. George's Church*. 1924, *Old Houses of Connecticut; A Lodging For*

The Night (Grolier Club); *Pedro Menéndez de Avilés* (Florida State Historical Society). 1925, *Early Domestic Architecture of Connecticut; Anchors of Tradition* (awarded the Institute medal for "most ably meeting the problems involved"); *Rasselas in the New World* (privately printed). 1929, *On the Duty of Civil Disobedience* (At the Sign of the Chorobates). 1930, *Loyalists in East Florida* (Florida State Historical Society). 1931, *Machu Picchu, A Citadel of the Incas; Wine Making for the Amateur* (Bacchus Club, New Haven). 1934, *The Adventures of Huckleberry Finn* (Limited Editions Club). In addition to *Huckleberry Finn*, 1934, Mr. Rollins designed two other Limited Edition Club titles: *Snowbound*, 1930; *The Way of All Flesh*, 1936.

[X-Y-Z] GEORG SALTER. Born 1897, Bremen, Germany, Artist, Designer, with H. Wolff Book Manufacturing Co., New York. Studied art at Berlin, Germany, 1919-1922. Designed theatrical and operatic stage sets and costumes for Deutsches Opernhaus and Grosse Volksoper, 1922-1927. Became interested in miniature work, book jackets and book decoration in 1924, dropped stage design in 1927, entering the Graphic Arts field. Director, Commercial Art Division, the Municipal Graphic Arts Academy (Berlin) 1931-1933. Moved to New York in November, 1934, connected with H. Wolff Book Manufacturing Co. Now doing book design, book jackets and book illustration for various publishers, including Simon and Schuster, Alfred A. Knopf, etc. "I know of no 'important' or 'unimportant' book I have ever done."

[X-Y-Z] MELVIN LOOS. Born 1897, New York, N. Y. Supervisor of Printing, Columbia University Press, New York. After the War (service in the Navy) with The Irving Press,

and Typographic Service Co., both of New York. Assistant Superintendent and Superintendent, The Printing House of William Edwin Rudge, Mt. Vernon, New York, 1925-1932. With Columbia University Press, N. Y., since 1932. Notable books designed: *Contemporary American Portrait Painters* (W. W. Norton & Co., 1929), *The English Dictionarie of 1923*, and *The Grand National, 1829-1930* (Huntington Press, 1930), *Catalog of the Lithographs of Joseph Pennell* (Little, Brown & Co., 1931), all printed by Rudge.

TYPE INDEX

A CATALOG OF SELECTED
DOVER BOOKS
IN ALL FIELDS OF INTEREST

A CATALOG OF SELECTED DOVER
BOOKS IN ALL FIELDS OF INTEREST

100 BEST-LOVED POEMS, Edited by Philip Smith. "The Passionate Shepherd to His Love," "Shall I compare thee to a summer's day?" "Death, be not proud," "The Raven," "The Road Not Taken," plus works by Blake, Wordsworth, Byron, Shelley, Keats, many others. 96pp. 5³⁄₁₆ x 8¼. 0-486-28553-7

100 SMALL HOUSES OF THE THIRTIES, Brown-Blodgett Company. Exterior photographs and floor plans for 100 charming structures. Illustrations of models accompanied by descriptions of interiors, color schemes, closet space, and other amenities. 200 illustrations. 112pp. 8⅜ x 11. 0-486-44131-8

1000 TURN-OF-THE-CENTURY HOUSES: With Illustrations and Floor Plans, Herbert C. Chivers. Reproduced from a rare edition, this showcase of homes ranges from cottages and bungalows to sprawling mansions. Each house is meticulously illustrated and accompanied by complete floor plans. 256pp. 9⅜ x 12¼.
0-486-45596-3

101 GREAT AMERICAN POEMS, Edited by The American Poetry & Literacy Project. Rich treasury of verse from the 19th and 20th centuries includes works by Edgar Allan Poe, Robert Frost, Walt Whitman, Langston Hughes, Emily Dickinson, T. S. Eliot, other notables. 96pp. 5³⁄₁₆ x 8¼. 0-486-40158-8

101 GREAT SAMURAI PRINTS, Utagawa Kuniyoshi. Kuniyoshi was a master of the warrior woodblock print — and these 18th-century illustrations represent the pinnacle of his craft. Full-color portraits of renowned Japanese samurais pulse with movement, passion, and remarkably fine detail. 112pp. 8⅜ x 11. 0-486-46523-3

ABC OF BALLET, Janet Grosser. Clearly worded, abundantly illustrated little guide defines basic ballet-related terms: arabesque, battement, pas de chat, relevé, sissonne, many others. Pronunciation guide included. Excellent primer. 48pp. 4⁵⁄₁₆ x 5¾.
0-486-40871-X

ACCESSORIES OF DRESS: An Illustrated Encyclopedia, Katherine Lester and Bess Viola Oerke. Illustrations of hats, veils, wigs, cravats, shawls, shoes, gloves, and other accessories enhance an engaging commentary that reveals the humor and charm of the many-sided story of accessorized apparel. 644 figures and 59 plates. 608pp. 6 ⅛ x 9¼.
0-486-43378-1

ADVENTURES OF HUCKLEBERRY FINN, Mark Twain. Join Huck and Jim as their boyhood adventures along the Mississippi River lead them into a world of excitement, danger, and self-discovery. Humorous narrative, lyrical descriptions of the Mississippi valley, and memorable characters. 224pp. 5³⁄₁₆ x 8¼. 0-486-28061-6

ALICE STARMORE'S BOOK OF FAIR ISLE KNITTING, Alice Starmore. A noted designer from the region of Scotland's Fair Isle explores the history and techniques of this distinctive, stranded-color knitting style and provides copious illustrated instructions for 14 original knitwear designs. 208pp. 8⅜ x 10⅞. 0-486-47218-3

CATALOG OF DOVER BOOKS

ALICE'S ADVENTURES IN WONDERLAND, Lewis Carroll. Beloved classic about a little girl lost in a topsy-turvy land and her encounters with the White Rabbit, March Hare, Mad Hatter, Cheshire Cat, and other delightfully improbable characters. 42 illustrations by Sir John Tenniel. 96pp. 5³⁄₁₆ x 8¼. 0-486-27543-4

AMERICA'S LIGHTHOUSES: An Illustrated History, Francis Ross Holland. Profusely illustrated fact-filled survey of American lighthouses since 1716. Over 200 stations — East, Gulf, and West coasts, Great Lakes, Hawaii, Alaska, Puerto Rico, the Virgin Islands, and the Mississippi and St. Lawrence Rivers. 240pp. 8 x 10¾. 0-486-25576-X

AN ENCYCLOPEDIA OF THE VIOLIN, Alberto Bachmann. Translated by Frederick H. Martens. Introduction by Eugene Ysaye. First published in 1925, this renowned reference remains unsurpassed as a source of essential information, from construction and evolution to repertoire and technique. Includes a glossary and 73 illustrations. 496pp. 6½ x 9¼. 0-486-46618-3

ANIMALS: 1,419 Copyright-Free Illustrations of Mammals, Birds, Fish, Insects, etc., Selected by Jim Harter. Selected for its visual impact and ease of use, this outstanding collection of wood engravings presents over 1,000 species of animals in extremely lifelike poses. Includes mammals, birds, reptiles, amphibians, fish, insects, and other invertebrates. 284pp. 9 x 12. 0-486-23766-4

THE ANNALS, Tacitus. Translated by Alfred John Church and William Jackson Brodribb. This vital chronicle of Imperial Rome, written by the era's great historian, spans A.D. 14-68 and paints incisive psychological portraits of major figures, from Tiberius to Nero. 416pp. 5³⁄₁₆ x 8¼. 0-486-45236-0

ANTIGONE, Sophocles. Filled with passionate speeches and sensitive probing of moral and philosophical issues, this powerful and often-performed Greek drama reveals the grim fate that befalls the children of Oedipus. Footnotes. 64pp. 5³⁄₁₆ x 8 ¼. 0-486-27804-2

ART DECO DECORATIVE PATTERNS IN FULL COLOR, Christian Stoll. Reprinted from a rare 1910 portfolio, 160 sensuous and exotic images depict a breathtaking array of florals, geometrics, and abstracts — all elegant in their stark simplicity. 64pp. 8⅜ x 11. 0-486-44862-2

THE ARTHUR RACKHAM TREASURY: 86 Full-Color Illustrations, Arthur Rackham. Selected and Edited by Jeff A. Menges. A stunning treasury of 86 full-page plates span the famed English artist's career, from *Rip Van Winkle* (1905) to masterworks such as *Undine, A Midsummer Night's Dream,* and *Wind in the Willows* (1939). 96pp. 8⅜ x 11. 0-486-44685-9

THE AUTHENTIC GILBERT & SULLIVAN SONGBOOK, W. S. Gilbert and A. S. Sullivan. The most comprehensive collection available, this songbook includes selections from every one of Gilbert and Sullivan's light operas. Ninety-two numbers are presented uncut and unedited, and in their original keys. 410pp. 9 x 12. 0-486-23482-7

THE AWAKENING, Kate Chopin. First published in 1899, this controversial novel of a New Orleans wife's search for love outside a stifling marriage shocked readers. Today, it remains a first-rate narrative with superb characterization. New introductory Note. 128pp. 5³⁄₁₆ x 8¼. 0-486-27786-0

BASIC DRAWING, Louis Priscilla. Beginning with perspective, this commonsense manual progresses to the figure in movement, light and shade, anatomy, drapery, composition, trees and landscape, and outdoor sketching. Black-and-white illustrations throughout. 128pp. 8⅜ x 11. 0-486-45815-6

Browse over 9,000 books at www.doverpublications.com

THE BATTLES THAT CHANGED HISTORY, Fletcher Pratt. Historian profiles 16 crucial conflicts, ancient to modern, that changed the course of Western civilization. Gripping accounts of battles led by Alexander the Great, Joan of Arc, Ulysses S. Grant, other commanders. 27 maps. 352pp. 5⅜ x 8½. 0-486-41129-X

BEETHOVEN'S LETTERS, Ludwig van Beethoven. Edited by Dr. A. C. Kalischer. Features 457 letters to fellow musicians, friends, greats, patrons, and literary men. Reveals musical thoughts, quirks of personality, insights, and daily events. Includes 15 plates. 410pp. 5⅜ x 8½. 0-486-22769-3

BERNICE BOBS HER HAIR AND OTHER STORIES, F. Scott Fitzgerald. This brilliant anthology includes 6 of Fitzgerald's most popular stories: "The Diamond as Big as the Ritz," the title tale, "The Offshore Pirate," "The Ice Palace," "The Jelly Bean," and "May Day." 176pp. 5⅜ x 8½. 0-486-47049-0

BESLER'S BOOK OF FLOWERS AND PLANTS: 73 Full-Color Plates from Hortus Eystettensis, 1613, Basilius Besler. Here is a selection of magnificent plates from the *Hortus Eystettensis,* which vividly illustrated and identified the plants, flowers, and trees that thrived in the legendary German garden at Eichstätt. 80pp. 8⅜ x 11. 0-486-46005-3

THE BOOK OF KELLS, Edited by Blanche Cirker. Painstakingly reproduced from a rare facsimile edition, this volume contains full-page decorations, portraits, illustrations, plus a sampling of textual leaves with exquisite calligraphy and ornamentation. 32 full-color illustrations. 32pp. 9⅜ x 12¼. 0-486-24345-1

THE BOOK OF THE CROSSBOW: With an Additional Section on Catapults and Other Siege Engines, Ralph Payne-Gallwey. Fascinating study traces history and use of crossbow as military and sporting weapon, from Middle Ages to modern times. Also covers related weapons: balistas, catapults, Turkish bows, more. Over 240 illustrations. 400pp. 7¼ x 10¼. 0-486-28720-3

THE BUNGALOW BOOK: Floor Plans and Photos of 112 Houses, 1910, Henry L. Wilson. Here are 112 of the most popular and economic blueprints of the early 20th century — plus an illustration or photograph of each completed house. A wonderful time capsule that still offers a wealth of valuable insights. 160pp. 8⅜ x 11. 0-486-45104-6

THE CALL OF THE WILD, Jack London. A classic novel of adventure, drawn from London's own experiences as a Klondike adventurer, relating the story of a heroic dog caught in the brutal life of the Alaska Gold Rush. Note. 64pp. 5³⁄₁₆ x 8¼. 0-486-26472-6

CANDIDE, Voltaire. Edited by Francois-Marie Arouet. One of the world's great satires since its first publication in 1759. Witty, caustic skewering of romance, science, philosophy, religion, government — nearly all human ideals and institutions. 112pp. 5³⁄₁₆ x 8¼. 0-486-26689-3

CELEBRATED IN THEIR TIME: Photographic Portraits from the George Grantham Bain Collection, Edited by Amy Pastan. With an Introduction by Michael Carlebach. Remarkable portrait gallery features 112 rare images of Albert Einstein, Charlie Chaplin, the Wright Brothers, Henry Ford, and other luminaries from the worlds of politics, art, entertainment, and industry. 128pp. 8⅜ x 11. 0-486-46754-6

CHARIOTS FOR APOLLO: The NASA History of Manned Lunar Spacecraft to 1969, Courtney G. Brooks, James M. Grimwood, and Loyd S. Swenson, Jr. This illustrated history by a trio of experts is the definitive reference on the Apollo spacecraft and lunar modules. It traces the vehicles' design, development, and operation in space. More than 100 photographs and illustrations. 576pp. 6¾ x 9¼. 0-486-46756-2

Browse over 9,000 books at www.doverpublications.com

CATALOG OF DOVER BOOKS

A CHRISTMAS CAROL, Charles Dickens. This engrossing tale relates Ebenezer Scrooge's ghostly journeys through Christmases past, present, and future and his ultimate transformation from a harsh and grasping old miser to a charitable and compassionate human being. 80pp. 5³⁄₁₆ x 8¼. 0-486-26865-9

COMMON SENSE, Thomas Paine. First published in January of 1776, this highly influential landmark document clearly and persuasively argued for American separation from Great Britain and paved the way for the Declaration of Independence. 64pp. 5³⁄₁₆ x 8¼. 0-486-29602-4

THE COMPLETE SHORT STORIES OF OSCAR WILDE, Oscar Wilde. Complete texts of "The Happy Prince and Other Tales," "A House of Pomegranates," "Lord Arthur Savile's Crime and Other Stories," "Poems in Prose," and "The Portrait of Mr. W. H." 208pp. 5³⁄₁₆ x 8¼. 0-486-45216-6

COMPLETE SONNETS, William Shakespeare. Over 150 exquisite poems deal with love, friendship, the tyranny of time, beauty's evanescence, death, and other themes in language of remarkable power, precision, and beauty. Glossary of archaic terms. 80pp. 5³⁄₁₆ x 8¼. 0-486-26686-9

THE COUNT OF MONTE CRISTO: Abridged Edition, Alexandre Dumas. Falsely accused of treason, Edmond Dantès is imprisoned in the bleak Chateau d'If. After a hair-raising escape, he launches an elaborate plot to extract a bitter revenge against those who betrayed him. 448pp. 5³⁄₁₆ x 8¼. 0-486-45643-9

CRAFTSMAN BUNGALOWS: Designs from the Pacific Northwest, Yoho & Merritt. This reprint of a rare catalog, showcasing the charming simplicity and cozy style of Craftsman bungalows, is filled with photos of completed homes, plus floor plans and estimated costs. An indispensable resource for architects, historians, and illustrators. 112pp. 10 x 7. 0-486-46875-5

CRAFTSMAN BUNGALOWS: 59 Homes from "The Craftsman," Edited by Gustav Stickley. Best and most attractive designs from Arts and Crafts Movement publication — 1903–1916 — includes sketches, photographs of homes, floor plans, descriptive text. 128pp. 8¼ x 11. 0-486-25829-7

CRIME AND PUNISHMENT, Fyodor Dostoyevsky. Translated by Constance Garnett. Supreme masterpiece tells the story of Raskolnikov, a student tormented by his own thoughts after he murders an old woman. Overwhelmed by guilt and terror, he confesses and goes to prison. 480pp. 5³⁄₁₆ x 8¼. 0-486-41587-2

THE DECLARATION OF INDEPENDENCE AND OTHER GREAT DOCUMENTS OF AMERICAN HISTORY: 1775-1865, Edited by John Grafton. Thirteen compelling and influential documents: Henry's "Give Me Liberty or Give Me Death," Declaration of Independence, The Constitution, Washington's First Inaugural Address, The Monroe Doctrine, The Emancipation Proclamation, Gettysburg Address, more. 64pp. 5³⁄₁₆ x 8¼. 0-486-41124-9

THE DESERT AND THE SOWN: Travels in Palestine and Syria, Gertrude Bell. "The female Lawrence of Arabia," Gertrude Bell wrote captivating, perceptive accounts of her travels in the Middle East. This intriguing narrative, accompanied by 160 photos, traces her 1905 sojourn in Lebanon, Syria, and Palestine. 368pp. 5⅜ x 8¼. 0-486-46876-3

A DOLL'S HOUSE, Henrik Ibsen. Ibsen's best-known play displays his genius for realistic prose drama. An expression of women's rights, the play climaxes when the central character, Nora, rejects a smothering marriage and life in "a doll's house." 80pp. 5³⁄₁₆ x 8¼. 0-486-27062-9

Browse over 9,000 books at www.doverpublications.com

DOOMED SHIPS: Great Ocean Liner Disasters, William H. Miller, Jr. Nearly 200 photographs, many from private collections, highlight tales of some of the vessels whose pleasure cruises ended in catastrophe: the *Morro Castle, Normandie, Andrea Doria, Europa,* and many others. 128pp. 8⅜ x 11¼. 0-486-45366-9

THE DORÉ BIBLE ILLUSTRATIONS, Gustave Doré. Detailed plates from the Bible: the Creation scenes, Adam and Eve, horrifying visions of the Flood, the battle sequences with their monumental crowds, depictions of the life of Jesus, 241 plates in all. 241pp. 9 x 12. 0-486-23004-X

DRAWING DRAPERY FROM HEAD TO TOE, Cliff Young. Expert guidance on how to draw shirts, pants, skirts, gloves, hats, and coats on the human figure, including folds in relation to the body, pull and crush, action folds, creases, more. Over 200 drawings. 48pp. 8¼ x 11. 0-486-45591-2

DUBLINERS, James Joyce. A fine and accessible introduction to the work of one of the 20th century's most influential writers, this collection features 15 tales, including a masterpiece of the short-story genre, "The Dead." 160pp. 5³⁄₁₆ x 8¼.
 0-486-26870-5

EASY-TO-MAKE POP-UPS, Joan Irvine. Illustrated by Barbara Reid. Dozens of wonderful ideas for three-dimensional paper fun — from holiday greeting cards with moving parts to a pop-up menagerie. Easy-to-follow, illustrated instructions for more than 30 projects. 299 black-and-white illustrations. 96pp. 8⅜ x 11.
 0-486-44622-0

EASY-TO-MAKE STORYBOOK DOLLS: A "Novel" Approach to Cloth Dollmaking, Sherralyn St. Clair. Favorite fictional characters come alive in this unique beginner's dollmaking guide. Includes patterns for Pollyanna, Dorothy from *The Wonderful Wizard of Oz,* Mary of *The Secret Garden,* plus easy-to-follow instructions, 263 black-and-white illustrations, and an 8-page color insert. 112pp. 8¼ x 11. 0-486-47360-0

EINSTEIN'S ESSAYS IN SCIENCE, Albert Einstein. Speeches and essays in accessible, everyday language profile influential physicists such as Niels Bohr and Isaac Newton. They also explore areas of physics to which the author made major contributions. 128pp. 5 x 8. 0-486-47011-3

EL DORADO: Further Adventures of the Scarlet Pimpernel, Baroness Orczy. A popular sequel to *The Scarlet Pimpernel,* this suspenseful story recounts the Pimpernel's attempts to rescue the Dauphin from imprisonment during the French Revolution. An irresistible blend of intrigue, period detail, and vibrant characterizations. 352pp. 5³⁄₁₆ x 8¼. 0-486-44026-5

ELEGANT SMALL HOMES OF THE TWENTIES: 99 Designs from a Competition, Chicago Tribune. Nearly 100 designs for five- and six-room houses feature New England and Southern colonials, Normandy cottages, stately Italianate dwellings, and other fascinating snapshots of American domestic architecture of the 1920s. 112pp. 9 x 12. 0-486-46910-7

THE ELEMENTS OF STYLE: The Original Edition, William Strunk, Jr. This is the book that generations of writers have relied upon for timeless advice on grammar, diction, syntax, and other essentials. In concise terms, it identifies the principal requirements of proper style and common errors. 64pp. 5⅜ x 8½. 0-486-44798-7

THE ELUSIVE PIMPERNEL, Baroness Orczy. Robespierre's revolutionaries find their wicked schemes thwarted by the heroic Pimpernel — Sir Percival Blakeney. In this thrilling sequel, Chauvelin devises a plot to eliminate the Pimpernel and his wife. 272pp. 5³⁄₁₆ x 8¼. 0-486-45464-9

AN ENCYCLOPEDIA OF BATTLES: Accounts of Over 1,560 Battles from 1479 B.C. to the Present, David Eggenberger. Essential details of every major battle in recorded history from the first battle of Megiddo in 1479 B.C. to Grenada in 1984. List of battle maps. 99 illustrations. 544pp. 6½ x 9¼. 0-486-24913-1

ENCYCLOPEDIA OF EMBROIDERY STITCHES, INCLUDING CREWEL, Marion Nichols. Precise explanations and instructions, clearly illustrated, on how to work chain, back, cross, knotted, woven stitches, and many more — 178 in all, including Cable Outline, Whipped Satin, and Eyelet Buttonhole. Over 1400 illustrations. 219pp. 8⅜ x 11¼. 0-486-22929-7

ENTER JEEVES: 15 Early Stories, P. G. Wodehouse. Splendid collection contains first 8 stories featuring Bertie Wooster, the deliciously dim aristocrat and Jeeves, his brainy, imperturbable manservant. Also, the complete Reggie Pepper (Bertie's prototype) series. 288pp. 5⅜ x 8½. 0-486-29717-9

ERIC SLOANE'S AMERICA: Paintings in Oil, Michael Wigley. With a Foreword by Mimi Sloane. Eric Sloane's evocative oils of America's landscape and material culture shimmer with immense historical and nostalgic appeal. This original hardcover collection gathers nearly a hundred of his finest paintings, with subjects ranging from New England to the American Southwest. 128pp. 10⅝ x 9. 0-486-46525-X

ETHAN FROME, Edith Wharton. Classic story of wasted lives, set against a bleak New England background. Superbly delineated characters in a hauntingly grim tale of thwarted love. Considered by many to be Wharton's masterpiece. 96pp. 5³⁄₁₆ x 8 ¼. 0-486-26690-7

THE EVERLASTING MAN, G. K. Chesterton. Chesterton's view of Christianity — as a blend of philosophy and mythology, satisfying intellect and spirit — applies to his brilliant book, which appeals to readers' heads as well as their hearts. 288pp. 5⅜ x 8½. 0-486-46036-3

THE FIELD AND FOREST HANDY BOOK, Daniel Beard. Written by a co-founder of the Boy Scouts, this appealing guide offers illustrated instructions for building kites, birdhouses, boats, igloos, and other fun projects, plus numerous helpful tips for campers. 448pp. 5³⁄₁₆ x 8¼. 0-486-46191-2

FINDING YOUR WAY WITHOUT MAP OR COMPASS, Harold Gatty. Useful, instructive manual shows would-be explorers, hikers, bikers, scouts, sailors, and survivalists how to find their way outdoors by observing animals, weather patterns, shifting sands, and other elements of nature. 288pp. 5⅜ x 8½. 0-486-40613-X

FIRST FRENCH READER: A Beginner's Dual-Language Book, Edited and Translated by Stanley Appelbaum. This anthology introduces 50 legendary writers — Voltaire, Balzac, Baudelaire, Proust, more — through passages from *The Red and the Black, Les Misérables, Madame Bovary,* and other classics. Original French text plus English translation on facing pages. 240pp. 5⅜ x 8½. 0-486-46178-5

FIRST GERMAN READER: A Beginner's Dual-Language Book, Edited by Harry Steinhauer. Specially chosen for their power to evoke German life and culture, these short, simple readings include poems, stories, essays, and anecdotes by Goethe, Hesse, Heine, Schiller, and others. 224pp. 5⅜ x 8½. 0-486-46179-3

FIRST SPANISH READER: A Beginner's Dual-Language Book, Angel Flores. Delightful stories, other material based on works of Don Juan Manuel, Luis Taboada, Ricardo Palma, other noted writers. Complete faithful English translations on facing pages. Exercises. 176pp. 5⅜ x 8½. 0-486-25810-6

Browse over 9,000 books at www.doverpublications.com

FIVE ACRES AND INDEPENDENCE, Maurice G. Kains. Great back-to-the-land classic explains basics of self-sufficient farming. The one book to get. 95 illustrations. 397pp. 5⅜ x 8½. 0-486-20974-1

FLAGG'S SMALL HOUSES: Their Economic Design and Construction, 1922, Ernest Flagg. Although most famous for his skyscrapers, Flagg was also a proponent of the well-designed single-family dwelling. His classic treatise features innovations that save space, materials, and cost. 526 illustrations. 160pp. 9⅜ x 12¼.
0-486-45197-6

FLATLAND: A Romance of Many Dimensions, Edwin A. Abbott. Classic of science (and mathematical) fiction — charmingly illustrated by the author — describes the adventures of A. Square, a resident of Flatland, in Spaceland (three dimensions), Lineland (one dimension), and Pointland (no dimensions). 96pp. 5⅜₆ x 8¼.
0-486-27263-X

FRANKENSTEIN, Mary Shelley. The story of Victor Frankenstein's monstrous creation and the havoc it caused has enthralled generations of readers and inspired countless writers of horror and suspense. With the author's own 1831 introduction. 176pp. 5⅜₆ x 8¼. 0-486-28211-2

THE GARGOYLE BOOK: 572 Examples from Gothic Architecture, Lester Burbank Bridaham. Dispelling the conventional wisdom that French Gothic architectural flourishes were born of despair or gloom, Bridaham reveals the whimsical nature of these creations and the ingenious artisans who made them. 572 illustrations. 224pp. 8⅜ x 11. 0-486-44754-5

THE GIFT OF THE MAGI AND OTHER SHORT STORIES, O. Henry. Sixteen captivating stories by one of America's most popular storytellers. Included are such classics as "The Gift of the Magi," "The Last Leaf," and "The Ransom of Red Chief." Publisher's Note. 96pp. 5⅜₆ x 8¼. 0-486-27061-0

THE GOETHE TREASURY: Selected Prose and Poetry, Johann Wolfgang von Goethe. Edited, Selected, and with an Introduction by Thomas Mann. In addition to his lyric poetry, Goethe wrote travel sketches, autobiographical studies, essays, letters, and proverbs in rhyme and prose. This collection presents outstanding examples from each genre. 368pp. 5⅜ x 8½. 0-486-44780-4

GREAT EXPECTATIONS, Charles Dickens. Orphaned Pip is apprenticed to the dirty work of the forge but dreams of becoming a gentleman — and one day finds himself in possession of "great expectations." Dickens' finest novel. 400pp. 5⅜₆ x 8¼.
0-486-41586-4

GREAT WRITERS ON THE ART OF FICTION: From Mark Twain to Joyce Carol Oates, Edited by James Daley. An indispensable source of advice and inspiration, this anthology features essays by Henry James, Kate Chopin, Willa Cather, Sinclair Lewis, Jack London, Raymond Chandler, Raymond Carver, Eudora Welty, and Kurt Vonnegut, Jr. 192pp. 5⅜ x 8½. 0-486-45128-3

HAMLET, William Shakespeare. The quintessential Shakespearean tragedy, whose highly charged confrontations and anguished soliloquies probe depths of human feeling rarely sounded in any art. Reprinted from an authoritative British edition complete with illuminating footnotes. 128pp. 5⅜₆ x 8¼. 0-486-27278-8

THE HAUNTED HOUSE, Charles Dickens. A Yuletide gathering in an eerie country retreat provides the backdrop for Dickens and his friends — including Elizabeth Gaskell and Wilkie Collins — who take turns spinning supernatural yarns. 144pp. 5⅜ x 8½. 0-486-46309-5

Browse over 9,000 books at www.doverpublications.com